Learning
from the
Dalai Lama

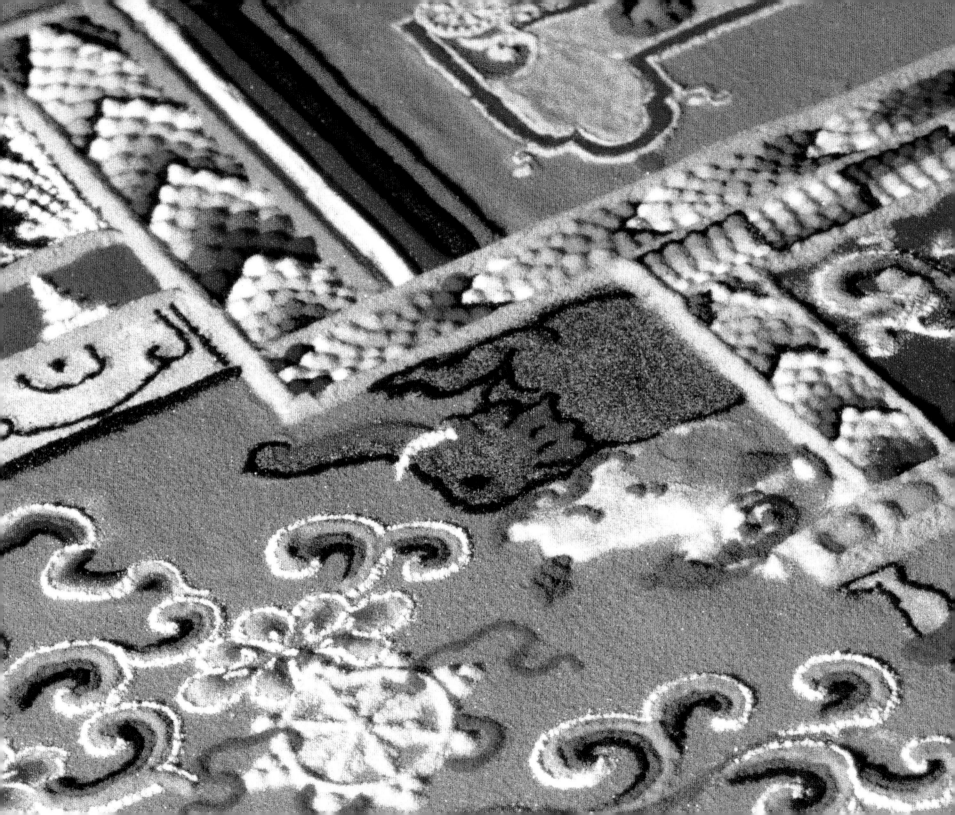

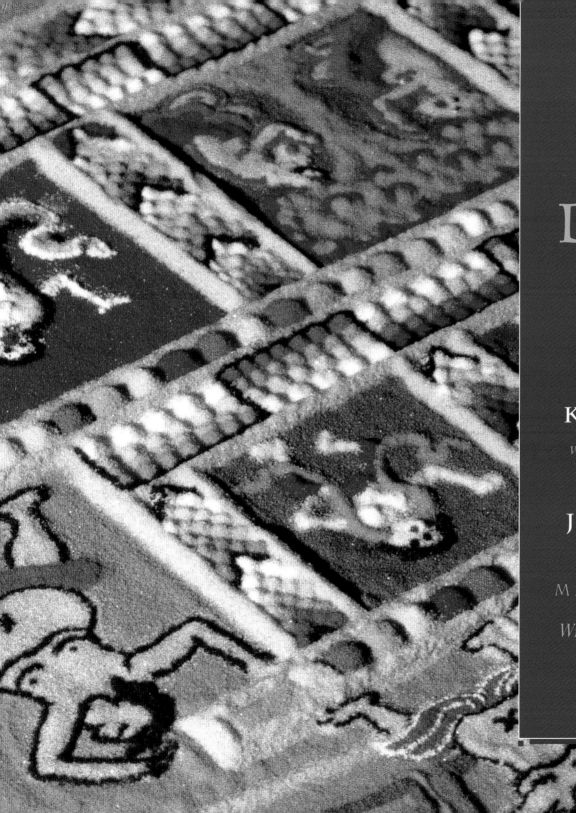

Learning from the Dalai Lama

Secrets of
the Wheel of Time

KAREN PANDELL
with BARRY BRYANT

Photographs by
JOHN B. TAYLOR

Concept by
MANUEL C. MENENDEZ

With a Foreword by Richard Gere

DUTTON CHILDREN'S BOOKS
NEW YORK

For Rob, whose love and support made my work on this book possible
K.P.

For G.D.
B.B.

For Dianne Dubler, without whose support nothing would be possible
J.B.T.

For my wife, Bettina, and sons Christopher, Michael, and Robbie
for their patience and guidance throughout the project
M.M.

A portion of the authors' proceeds from this book has been donated to His Holiness the Fourteenth Dalai Lama
and also to two organizations working on behalf of Tibet: the Samaya Foundation and the Tibet Fund.

All of the photographs in this book were taken by John Bigelow Taylor, except for the following: page 16: From *In Exile from the Land of the Snows* by John Avedon. Copyright © 1935 AP/Wide World Photos • page 17 *(top)*: From the film *Compassion in Exile.* Copyright © 1992 Lemle Pictures, Inc. • page 20 *(right)*: Courtesy of the White House Archives • page 31: Photograph by Gregory Durgin. Courtesy of the Samaya Foundation • pages 36–38: Copyright © Gladys Ostrom and Karen Pandell. The sculpture on page 11 appears courtesy of Mokotoff Asian Arts, New York, New York.

Library of Congress Cataloging-in-Publication Data

Pandell, Karen.
Learning from the Dalai Lama: secrets of the wheel of time / Karen Pandell with Barry Bryant;
photographs by John B. Taylor; concept by Manuel C. Menendez; with a foreword by Richard Gere.
p. cm. Includes index. ISBN 0-525-45063-7 (hc)
1. Buddhism—China—Tibet—Juvenile literature. 2. Kālachakra (Tantric rite)—Juvenile literature.
3. Bstan-'dzin-rgya-mtsho, Dalai Lama XIV, 1935– —Juvenile literature.
I. Bryant, Barry, 1940– . II. Taylor, John Bigelow. III. Title.
BQ7618.P36 1995 294.3'923—dc20 95-6984 CIP AC

Published in the United States 1995 by Dutton Children's Books, a division of Penguin Books USA Inc.
375 Hudson Street, New York, New York 10014

DESIGNED BY CHRIS WELCH
Printed in Hong Kong First Edition 10 9 8 7 6 5 4 3 2 1

Contents

Acknowledgments

The four contributors and their editor would like to thank the following people for their invaluable help in the making of this book: Jean and Francis Paone and the Tibet Center; Rinchen Dharlo; Richard Gere; Dianne Dubler; Gregory Durgin; Lama Pema Wang Dak; Gladys, Andy, Mark, and Matthew Ostrom; Mia Grosjean; Frank Douglas, Esq.; Barbara Hoffman, Esq.; the Volunteer Lawyers for the Arts; Jensine Andresen, Ph.D.; Deborah Moldow; Nina Reznick; Greg Turnbull; Scott Hoyt; Mickey Lemle; Wayne Furman; Andy Kulmatiski.

Also helpful to Karen Pandell were many excellent books from Wisdom Publications, in particular *Kalachakra Tantra: Rite of Initiation,* by Tenzin Gyatso and Jeffrey Hopkins, 1989. The following libraries generously allowed her use of their collections: the Schenectady County Public Library, the Union College Library, the State University of New York at Albany Library, and the New York Public Library (including the Office of Special Collections and the Wertheim Study).

We also gratefully and humbly acknowledge Tenzin Gyatso, His Holiness the Fourteenth Dalai Lama, and the monks of Namgyal Monastery.

Foreword

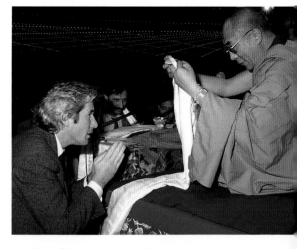

Actor Richard Gere requesting the Kalachakra Initiation from His Holiness the Fourteenth Dalai Lama at Madison Square Garden

In October 1991, a sand painting representing the divine celestial mansion of Kalachakra was constructed on the stage of the Paramount Theater at Madison Square Garden in New York City. This ceremony was the crowning event in our International Year of Tibet celebration, four years in the making. His Holiness the Dalai Lama was the master and spiritual friend who led 4,000 of us through the two-week initiation, planting purifying seeds of wisdom and compassion in our minds and hearts.

When I first requested His Holiness to offer this ancient initiation in the center of Manhattan, at one of its most famous landmarks, he was very pleased. It was exciting that His Holiness and the sand mandala would be situated just above Penn Station, one of the busiest train stations in the world. Millions of people every day would be passing under and through the powerful healing energy of the Kalachakra, embodied in the person of the Dalai Lama and in the magically prepared sand mandala. His Holiness laughed and said that he, too, liked the prospect of this kind of mysterious communication.

This book represents a clear and simple beginning to understanding the context of Kalachakra and the meaning, importance, and craft of the Kalachakra sand mandala. It includes a brief history of the Buddha and his wondrous teachings; also included is a biography of His Holiness the Dalai Lama—a great and completely trustworthy friend to all who have had the good fortune to encounter him, either in person or through his prolific writings.

I urge you to continue your exploration of Buddhism within His Holiness's protection circle. May this book continue the work of transforming hatred and ignorance into love and universal responsibility, and may all beings achieve total and complete happiness in this very life.

Richard Gere
February 1995

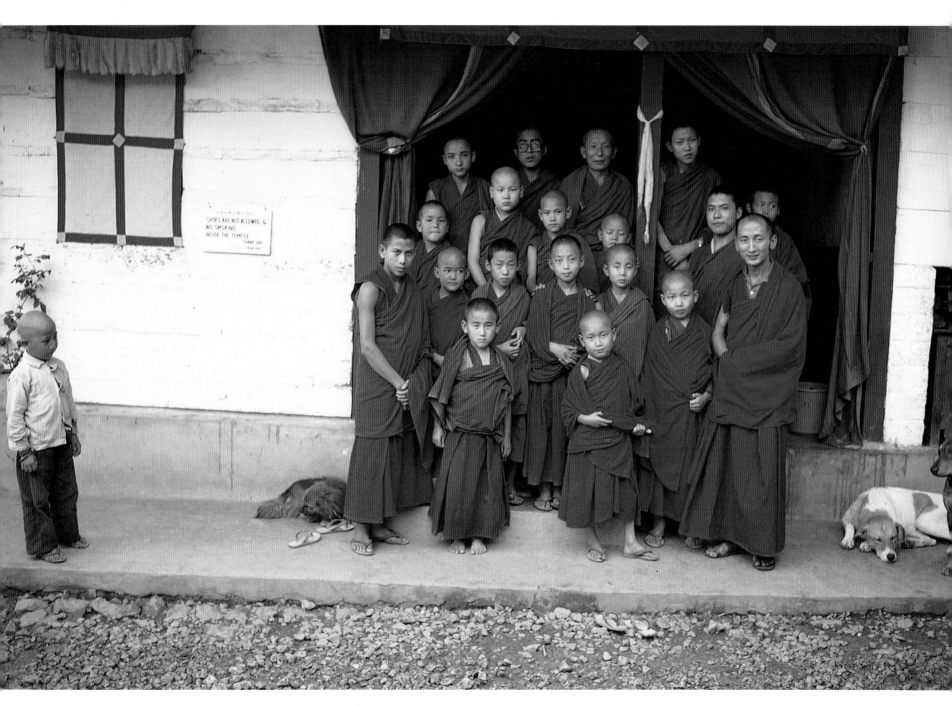

Young monks posing at a monastery in Dharmsala, India, as a boy admiringly looks on

The Roots of Buddhism

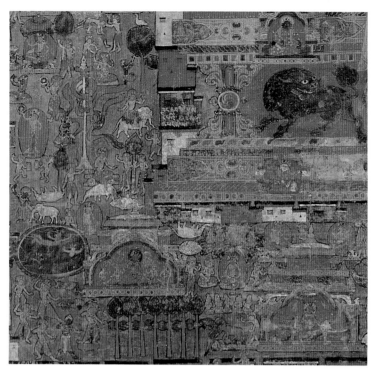

The religion of Buddhism was founded in India over 2,500 years ago. Like a very old tree with deep roots and innumerable branches, it continues to flourish today. Approximately 500 million people—living all over the world, particularly in India and Asia—consider themselves followers of the Buddha. Although Buddhists worship differently from region to region, all share a common goal: to reach a state of freedom from suffering called enlightenment. Buddhist masters teach their followers that the best way to achieve enlightenment is through the daily practice of compassion. Buddhists strive to care deeply for their fellow humans and also for every living creature, from the tiniest insect to the mightiest whale. This tradition of compassion began in the life of the Buddha himself and has been upheld by generation after generation ever since.

HOW DID BUDDHISM BEGIN?

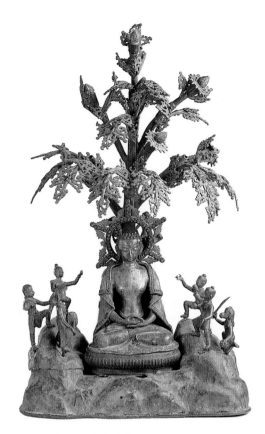

Around 563 B.C., a child was born in northern India who later would become known as the Buddha. This child, named Siddhartha by his parents, was the only heir to a small kingdom. At his birth, wise men prophesied that someday he would come to know great sorrow and would give up his throne. To prevent such a catastrophe, Siddhartha's father isolated the prince in a magnificent palace, keeping him from any knowledge of suffering or death and satisfying his every wish. Eventually, Siddhartha grew up, married, and even had a child of his own, all within the palace walls.

Legend tells that one day Siddhartha heard a group of servants talking about an extraordinarily beautiful garden of trees beyond the palace walls. He wished very much to visit this garden, and so asked his father for permission. The king reluctantly agreed, but first ordered his guards to whitewash the village and to clear all signs of suffering and decay from the garden grounds. In the commotion, one very feeble old man was overlooked. Siddhartha came upon him and was amazed. He had never before seen anyone so old and had not known that elderly people very often grow weak and sick. He also had never realized that someday everyone must die.

Siddhartha no longer could be content with his princely life, sheltered from the problems of the world. Despite his father's objections, he began to leave the palace more and more frequently. Soon he met a wanderer dressed in rags. This man explained to Siddhartha that he had purposefully abandoned all his wealth and material possessions in the belief that he could find true peace and happiness inside himself. Inspired, Siddhartha left home to undertake his own spiritual journey, bringing with him only a robe, sandals, and a bowl for begging. As the seers had foretold, the prince renounced his throne at the age of twenty-eight and began to search for enlightenment. He could not imagine what he was going to discover; he only knew that he had to find an end to the suffering of all beings.

The Buddha beneath the bodhi tree, reaching enlightenment in spite of any distractions

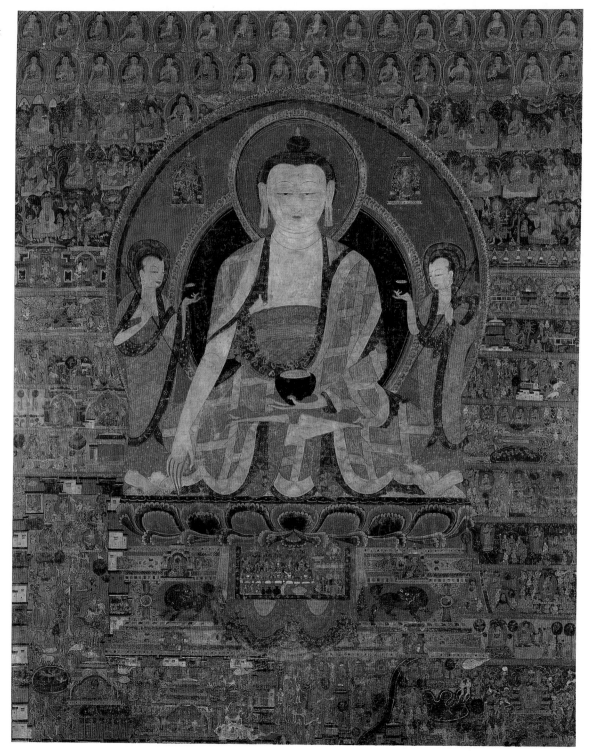

For seven years, Prince Siddhartha traveled throughout north central India, learning from great religious masters and practicing meditation. To meditate means to focus on a single point or object, quieting and calming the mind. There are many ways to meditate.

Buddhists believe that when our minds are quieted and purified through meditation it is possible for us to experience wisdom and to feel deep compassion for others. Siddhartha meditated for forty-nine days under a tree now called the *bodhi* tree until he became the Buddha, or "awakened one."

Buddhists believe that, after becoming enlightened, the Buddha could have left the world that we know to stay forever in a pure land inhabited only by enlightened beings, a timeless realm where there is no suffering of any kind. But instead he chose to remain on Earth so that he could help others reach enlightenment. At a deer park, he preached his first sermon. From there he continued to travel, skillfully teaching as he went. The teachings of the Buddha, handed down by oral tradition and in writing ever since, are called the *dharma* and are the sacred law of Buddhism.

Part of the dharma is the belief in reincarnation. Buddhists believe that each of us has had countless previous lives and that, after death, we will be reborn or reincarnated to live other lives until we attain enlightenment and are liberated from this endless cycle. Buddhists also believe in a force called *karma*. Karma means that the good and bad deeds we do in one lifetime will determine our happiness in present and future lifetimes. Buddhists work to improve their karma by ridding their lives of evil and selfish deeds and devoting themselves to acting kindly toward others.

Buddhism identifies many thousands of deities, male and female, each of whom represents an aspect of the enlightened mind. These deities—some fierce, some kind—are believed to help spiritual journeyers to improve their karma and complete the path to enlightenment.

Buddhists believe that, by following Prince Siddhartha's example, each one of us in our own time also can reach enlightenment.

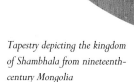

Tapestry depicting the kingdom of Shambhala from nineteenth-century Mongolia

TIBETAN BUDDHISM AND THE TEACHINGS OF KALACHAKRA

Surrounded by imposing, snowbound mountain ranges and currently under Chinese rule, the country of Tibet has been a strong center of Buddhism since the seventh century A.D. Tibetan Buddhists believe that somewhere in the north of their land lies a mystical kingdom that cannot be reached by any highway or footpath. This kingdom is called Shambhala, and, over the centuries, its enlightened kings are believed to be guarding the most secret teachings of the Buddha. According to a prophecy, these teachings will be revealed at a time when our world is at war. Then the king of Shambhala will lead a great army to destroy the forces of evil. At that moment, all suffering on Earth will be eliminated. But the inhabitants of Shambhala already live in peace and harmony. They no longer suffer from anger, greed, hunger, war, or pain. To reach this land of perfect happiness, travelers must take an inward journey.

The teachings of Buddhism are filled with many symbols and images of a perfect world, which are examples for our own world to imitate. Thinking about and visualizing these images—seeing them in the mind's eye—can help those who are working toward enlightenment. One of the most sacred teachings in Tibetan Buddhism is called Kalachakra. The Kalachakra teaching is believed to have been passed by the Buddha himself to Suchandra, an ancient king of Shambhala. Each of Suchandra's successors passed it down in turn until the teaching re-entered India in 1027. The Kalachakra teaching came to Tibet and was entrusted to a religious leader called the Dalai Lama in the eighteenth century. Kalachakra, named for a deity who inhabits the palace of

enlightenment in Buddhist tradition, is the authorized ceremony for students who wish to be initiated into the realm of enlightened beings.

In Sanskrit, the ancient language of India, *kala* means "time" and *chakra* means "wheel." The Buddha taught the Wheel of Time to help his followers imagine what enlightenment would be like, giving them a *mandala* to serve as a visual guide.

A mandala is a circular picture that portrays a mystical representation of the universe. The Wheel of Time mandala represents the universe of the enlightened mind by picturing it as the palace of the deity Kalachakra in a painting of sand. The Kalachakra sand mandala is painted with sands made from a soft, white Himalayan stone. The stone is crushed into a fine sand, then dyed with the fourteen brilliant colors that are used to form the mandala's intricate images. At the end of the ceremony, the sand painting is intentionally dismantled. The mandala must be constructed again and again for each new group of initiates.

The Potala Palace at Lhasa, the capital of Tibet and the traditional home of the Dalai Lama

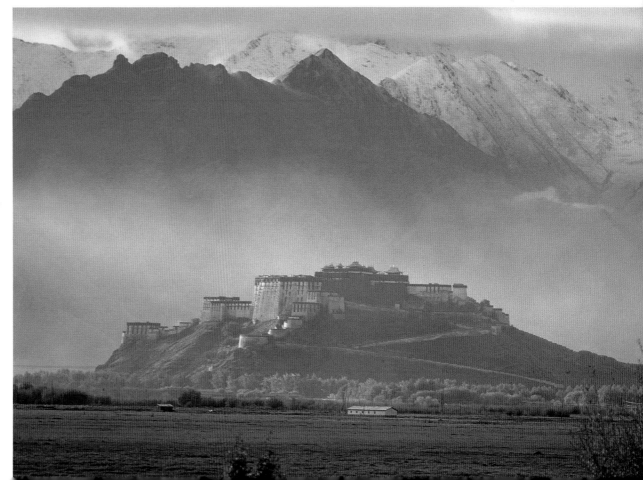

Students who wish to experience Kalachakra must receive the initiation ceremony from a qualified master. The perfect, inner world of Kalachakra is so pure that it should not be seen by anyone who has not yet received the initiation. However, anyone who earnestly wishes to see the mandala may try, male or female, adult or child. A Ritual Master leads the initiation ceremo-

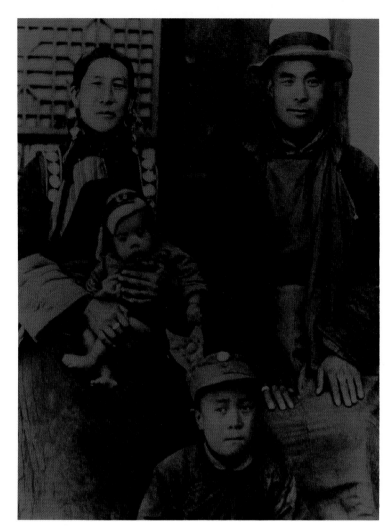

The young Dalai Lama with his natural family, shortly after his birth

ny and helps the students prepare themselves to see the mandala. Today the Fourteenth Dalai Lama of Tibet is an authorized master of the Kalachakra teachings.

THE SEARCH FOR AND DISCOVERY OF THE FOURTEENTH DALAI LAMA

Tibetan Buddhists believe that when one Dalai Lama dies, he is reincarnated as a child of the next generation. In 1933, on the night when the Thirteenth Dalai Lama died, word of his death spread immediately. A huge crowd gathered at his palace, hoping to discover clues about the new Dalai Lama's identity. The next morning, these people saw the shape of a rainbow form in the eastern sky. *The Dalai Lama will be reborn in the east,* everyone thought.

One group of *lamas,* or religious masters, went to a sacred lake to pray for more clues about the reincarnated Dalai Lama. As they prayed, a vision appeared in the water—an image of a three-storied monastery with roofs of jade green and gold. Nearby stood a small house tiled in turquoise. Search parties were sent out in all directions to look for this monastery. When, four years later, the party in the east came to the monastery of Kumbum, they recognized it to be the one from the vision. In the nearby village stood a house with turquoise tiles. And the family that lived in the house had children, including a little boy who was two years old.

The lamas visited the turquoise-tiled house, disguising themselves as common servants. Surprisingly, the two-year-old boy ran to one of them and sat on his lap. Then the boy pulled out a rosary that the lama was wearing around his neck and said, "This is mine." That rosary had belonged to the Thirteenth Dalai Lama.

Tibetan Buddhists believe that certain small children can recognize objects and people from their previous lives. So they presented the boy with a series of the former Dalai Lama's possessions, side by side with similar objects. When the boy correctly chose the real possessions, one after the other, he had passed the first test. He would soon be recognized as the reincarnation of the Dalai Lama.

The Dalai Lama at age four

His Holiness the Fourteenth Dalai Lama, as his followers refer to him, was given his monk's name of Tenzin Gyatso and was taken to the holy city of Lhasa at the age of four. There he began his long and arduous training.

According to Tibetan custom, both boys and girls can choose to enter religious orders. Monks can begin their religious studies at the very young age of two or three. Young monks are called *rapjungs,* or "pre-novices." They study and work in order to take part in the dawn-to-dusk ceremonies of the monastery. Rapjungs wear brownish red robes. Young nuns are called *rapjungmas.*

Between the ages of fifteen and twenty-five, rapjungs may take more vows to become *getsuls,* or "novices." When they complete their training, they take further vows to become *gelongs,* or fully ordained Tibetan Buddhist monks. Both getsul and gelong monks wear red robes, with saffron yellow shirts. Female students who reach these levels in the nunnery are called *getsulmas,* who are novices, and *gelongmas,* who are fully ordained nuns. Some getsul and gelong monks and nuns, as well as some laypeople, reach another level of religious training and become lamas.

The term *lama* in Tibetan Buddhism is equivalent to the Sanskrit word *guru,* which means "perfect teacher." The word *dalai,* from the title of the Tibetan spiritual leader, is the Mongolian word for "ocean"—so the term *Dalai Lama* is often translated as "Ocean of Wisdom."

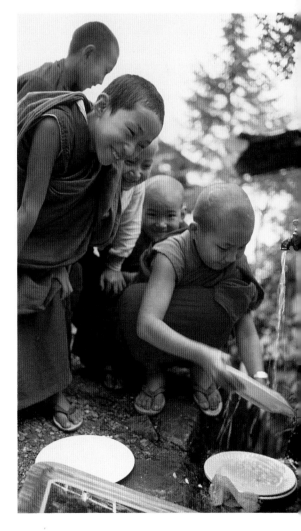

Young monks washing dishes at the Dip Tse Chok Ling Monastery in Dharmsala, India

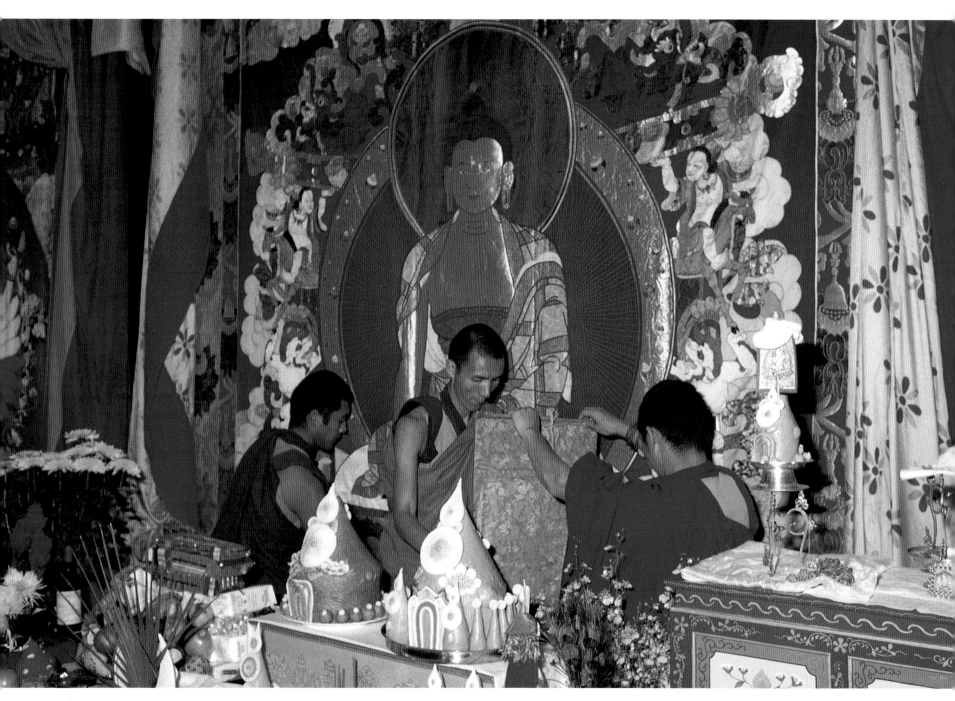

Monks from the Namgyal Monastery assisting in the preparations for the Kalachakra ceremony

PART II

Continuing
an Ancient Ritual

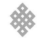

THE TEENAGE AND ADULT YEARS
OF THE DALAI LAMA

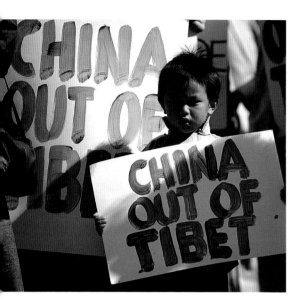

A young protestor holds a sign during a recent demonstration at the United Nations

In 1950, China invaded its neighbor, Tibet. Political conditions in the country became unstable. Because of the unrest, the current Dalai Lama assumed the spiritual and political leadership of his country at the young age of fifteen. For nine years, he and his people struggled against their Chinese oppressors, with the Dalai Lama urging his followers to use only nonviolent means of protest, in keeping with the value of *ahimsa,* or nonviolence.

Finally, the Dalai Lama went into exile in order to escape capture and imprisonment by the Chinese. He knew that it was important for him to stay alive and free as a symbol of hope for the Tibetan people. In 1959, he left his palace in the middle of the night with a party of family members, officials, and guards, all dressed as common soldiers. They rode on horseback for three weeks, crossing the Himalayas into India. Since that time, the Dalai Lama has led his government-in-exile from the Indian Himalayan town of Dharmsala.

Buddhists revere His Holiness the Fourteenth Dalai Lama because they believe he embodies the compassion of the Buddha, responding to the suffering of others with great caring. He is also held in high regard by non-Buddhists. In 1989, he received the Nobel

His Holiness the Fourteenth Dalai Lama with President Bill Clinton and Vice President Al Gore

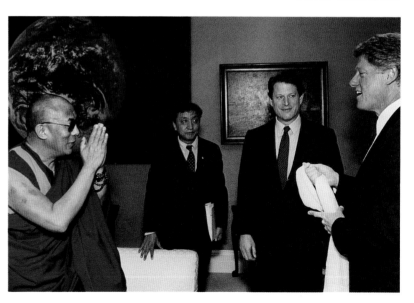

20

Peace Prize for his tireless commitment to nonviolence and his work on behalf of global peace.

All over the world, the Dalai Lama has taught people the meaning of compassion, saying, "My religion is kindness."

A MANDALA IN NEW YORK CITY

Since the Dalai Lama went into exile in 1959, he has given the Kalachakra Initiation more than eighteen times, hoping to reach many people all over the world with its message of peace. In October 1991, the Dalai Lama came to the Paramount Theater at Madison Square Garden in New York City. Over 4,000 students traveled to this event, from near and far. The opportunity to participate in a Kalachakra Initiation may come only once in a lifetime.

There are three main parts to the ceremony. First, there are eight days of preparation rituals, during which the monks make the mandala, using special sands they have brought from the Himalayas. Then the students are initiated, after which they are allowed to see the completed sand mandala. The ceremony ends when the monks release the positive energy of the mandala into the everyday world through a final ritual.

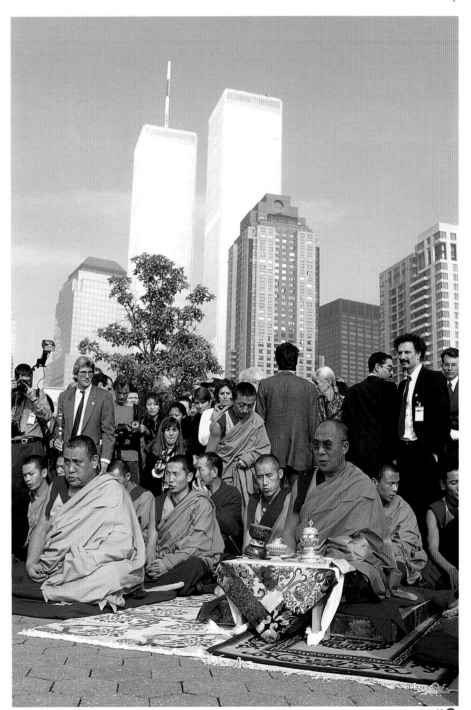

His Holiness the Fourteenth Dalai Lama and attendants in New York City

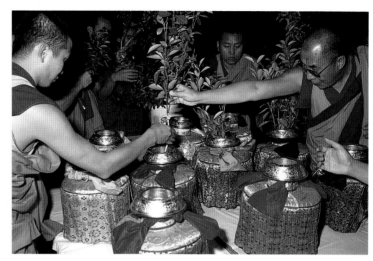

The Vajra Master blessing sacred branches for use in the ceremony

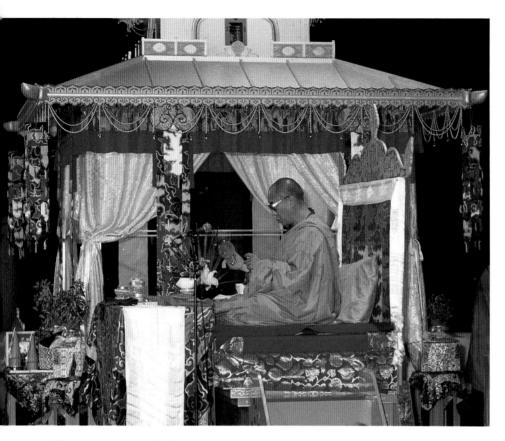

The Vajra Master near the thekpu

The Ritual Master and authorized teacher of the Kalachakra Initiation is called the Vajra Master. At the Madison Square Garden initiation, the Dalai Lama himself was the Vajra Master. He had sixteen monks from the Namgyal Monastery in Dharmsala, India, to assist him, each of whom had studied the sacred text of Kalachakra for many years before joining the ceremonies. It is a great honor to learn the Kalachakra teaching. Just memorizing the hundreds of symbols in the Kalachakra mandala design and learning how to apply the sand takes at least two years of intense study.

Many beautiful objects are used in the Kalachakra rituals. The *thekpu* is the special house where the mandala is built. There is also a throne covered in golden brocade

where the Dalai Lama sits to give the initiation. An altar to the Kalachakra deity contains elaborate offerings and ritual objects. Large silk tapestries of the Buddha, Kalachakra, and various protector deities are hung around the thekpu, the throne, and the altar.

On the first day of the ceremony, a representative of the students requests that the Vajra Master give the initiation, and the Vajra Master consents, showing his great compassion for his students. Next the Vajra Master, in this case His Holiness the Dalai Lama, asks the local spirits for permission to use their home. Usually the spirits at first do not want to cooperate. To appease them, the sixteen monks perform the Dance of the Earth, making symbolic gestures with their hands and feet. The prayers, music, and dance subdue all interfering spirits.

After the dance, the Dalai Lama receives permission to proceed with the ceremony from Tenma, the earth spirit, on behalf of all the local spirits. The mandala will house many of the thousands of deities found in Tibetan Buddhism during the ceremony. Symbolic daggers are now placed around the mandala site to protect it.

All the objects to be used in the many rituals must be blessed by the Dalai Lama, including the string that is used to draw the mandala and the colored sands.

To begin the drawing, the ceremonial string is dipped into liquid white chalk. The Vajra Master and four assistants called gatekeepers stand on opposite sides of the mandala platform. Holding one end taut while an assistant holds the other end, the Vajra Master plucks the string, and the chalk falls onto the platform to make the first lines of the sand mandala. Each time the Vajra Master plucks the string, the snap sounds a blessing from the Buddha for the construction of the sand mandala.

When all the lines have been drawn, the mandala de-

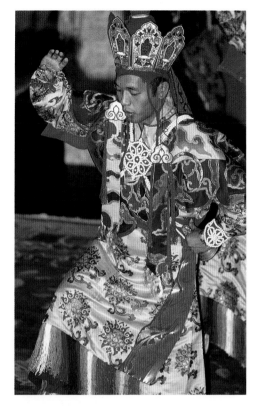

Namgyal monks perform the ceremonial Dance of the Earth.

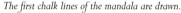

The first chalk lines of the mandala are drawn.

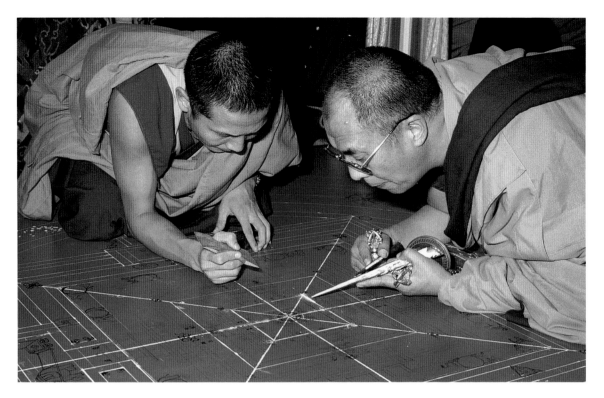

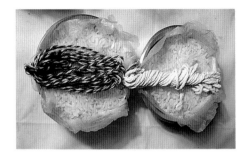

Sacred strings used to draw and bless the
mandala

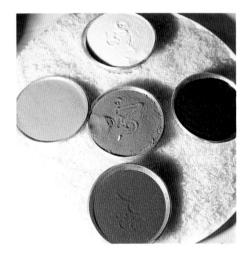

The sacred sands

sign looks like an enormous blueprint, seven feet in diameter. It has taken the Dalai Lama and the gatekeepers two days to make this drawing. So far, no color has been added.

On the third day, water mixed with a special spice, saffron, is scattered on the lines of the mandala; with it, the Vajra Master rubs out certain lines on the mandala blueprint, opening the entranceways for the 722 deities who will reside in the mandala during the ceremony. These deities represent different aspects of the nature of the Buddha, such as his wisdom and compassion. In order to enter our world, they need a clean and pure place to stay. Grains of wheat are also placed on the mandala at this time, representing cushions where the gods and goddesses are invited to sit.

Making three parallel lines, the Dalai Lama then puts the first grains of red, white, and black sand near the center of the mandala. These three lines represent the body,

speech, and mind of the Buddha. Then the monks serving as gatekeepers continue to apply the sand. Starting in the middle and working outward, they use a long serrated funnel called a *chakpu* to create the detailed designs of the Kalachakra they so painstakingly have learned and memorized. When two chakpus are rasped together, the colored sand flows out evenly and smoothly in a thin stream onto the mandala. However, even with much practice, the sand is tricky to handle, and mistakes may happen. The monks use a wooden scraper called a *shinga* to straighten lines and to fix any errors. For large areas of color, the monks sometimes apply the sand with their fingers.

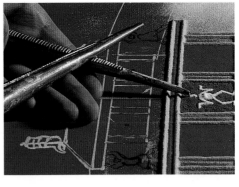

Rasping two chakpus *together produces a smooth flow of sand.*

Ritual Assistants pull the curtains shut around the completed mandala.

A wooden shinga *helps straighten any mistakes.*

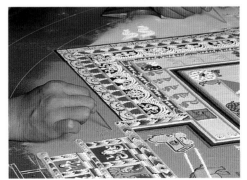

A pin is used for the tiniest, most intricate designs.

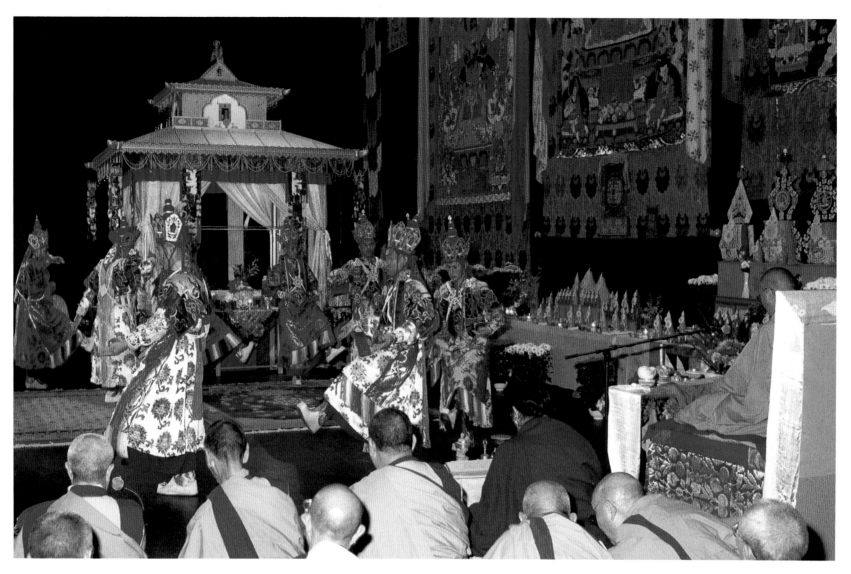

Ritual Assistants bless the mandala.

On the eighth day, the mandala is finally completed, and sacred vases are placed around it. The sides of the thekpu are covered with curtains so that the mandala will not be seen before the proper time.

The Dalai Lama thanks the spirits and deities for their cooperation by making offerings to them. The monks play sacred music with bells, gongs, drums, and huge twelve-

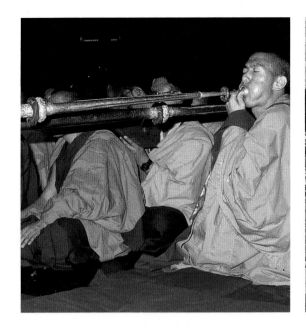

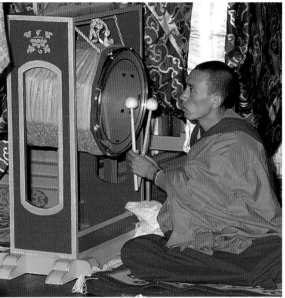

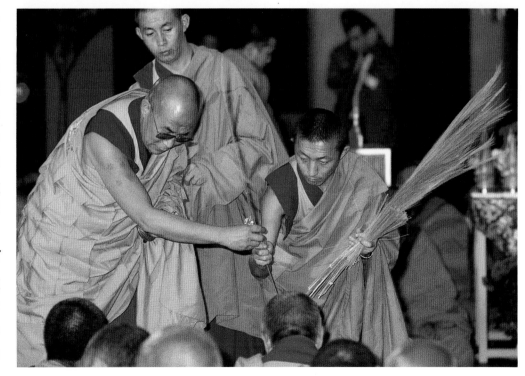

foot horns. They also do a dance of celebration that lasts an hour and a half.

On the ninth day, after the Dalai Lama and the monks finish their morning prayers and meditation, the students arrive for the first time. Those who wish to be initiated into the practice of the Kalachakra teachings take a vow to have compassion toward all living things, to work for the benefit of others, and never to reveal the secrets of the mandala.

The students are each given two stalks of *kusha* grass, because the Buddha was sitting on kusha grass under the bodhi tree when he became enlightened. The Dalai Lama tells the students to put the long stalk of kusha grass

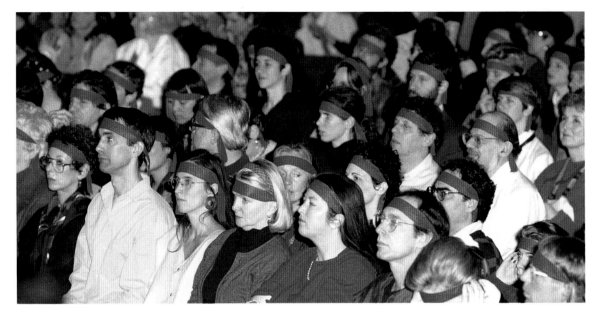

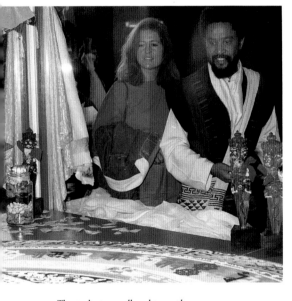

The students are allowed to see the mandala for the first time.

under their mattresses and the short stalk under their pillows. This will help the students to remember and study their dreams that night.

Each student also receives a red blindfold to place over his or her forehead as a symbol, since the students are not yet spiritually ready to see the sand mandala.

The next day, after the students have made pledges of good behavior, the Dalai Lama asks Kalachakra to open their eyes. The students now remove their blindfolds, symbolically removing the darkness of ignorance. They are now prepared to "see" the mandala.

Next, the Vajra Master gives the students what are called the Seven Childhood Initiations. These initiations will help the students to be reborn during the ceremony as ideal persons, fit to enter the perfect world of the mandala. Each initiation corresponds to a significant event in the life of a child. The seven initiations represent a child's receiving a name, having a first bath, getting a first haircut, first experiencing the five senses, getting pierced ears, saying a first word, and learning to read.

After the students have been "reborn" by completing the childhood initiations, they may enter the ideal world of the Wheel of Time—the universe of enlightenment, ruled by the deity Kalachakra.

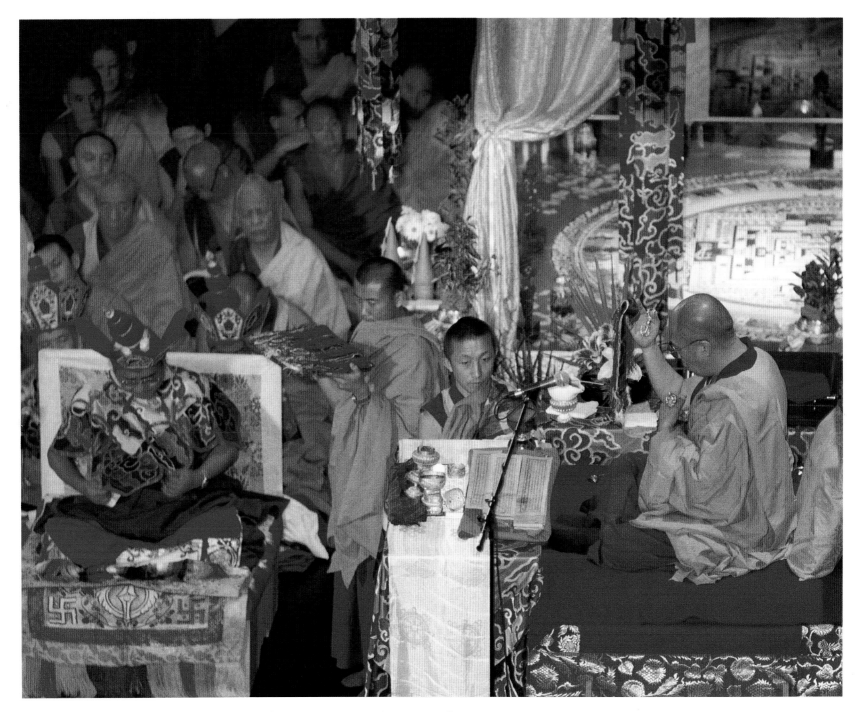

The Vajra Master, His Holiness the Fourteenth Dalai Lama (right), *on his throne near the completed Wheel of Time*

ENTERING THE WHEEL OF TIME

To imagine at least part of what the monks and the students see when they enter the world of Kalachakra, we can use our own inner eyes. Look at the picture here to help you.

The Kalachakra sand mandala shows the 722 gods and goddesses as well as the palace in which they dwell. The four faces of the deity named Kalachakra are also pictured. To find the representations of his faces in the mandala, look for the four wedge-shaped areas of color within the circle. The blue-black wedge, or face, at the bottom of the picture looks east. The red face looks south. The white face looks north. The orange or yellow face at the top looks west. To exercise your imagination, try to envision what the mandala looks like from the deity's point of view inside the mandala, at its center. The deity's black face looks forward, his red face looks to his right, his white face looks to his left, and his yellow face looks backward.

There are representations in the mandala of 721 additional deities, as well as animals, flowers, and jewels. To find the palace of Kalachakra where the gods and goddesses live, look for the largest square within the circle. This building has five levels, and each level consists of a square with four walls. In the middle of each wall is an entrance. In order to reach the most secret central chambers of the palace, initiates must travel through the maze of squares. Each square represents a different aspect of an enlightened being.

The mandala appears to be flat, but you can use your imagination to picture it rising up three-dimensionally toward its lotus-flower center. To trace the path of enlightenment, enter the black eastern doorway from the outside of the building. You will find yourself on the first level of the palace. This level is called the mandala of the *enlightened body*. Halfway inside the body mandala is another set of four walls and an entrance. When you proceed through the entrance, you have reached the *enlightened speech* mandala. Halfway inside, there is another set of walls and entrances where you will discover an even higher level called the *enlightened mind* mandala.

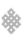

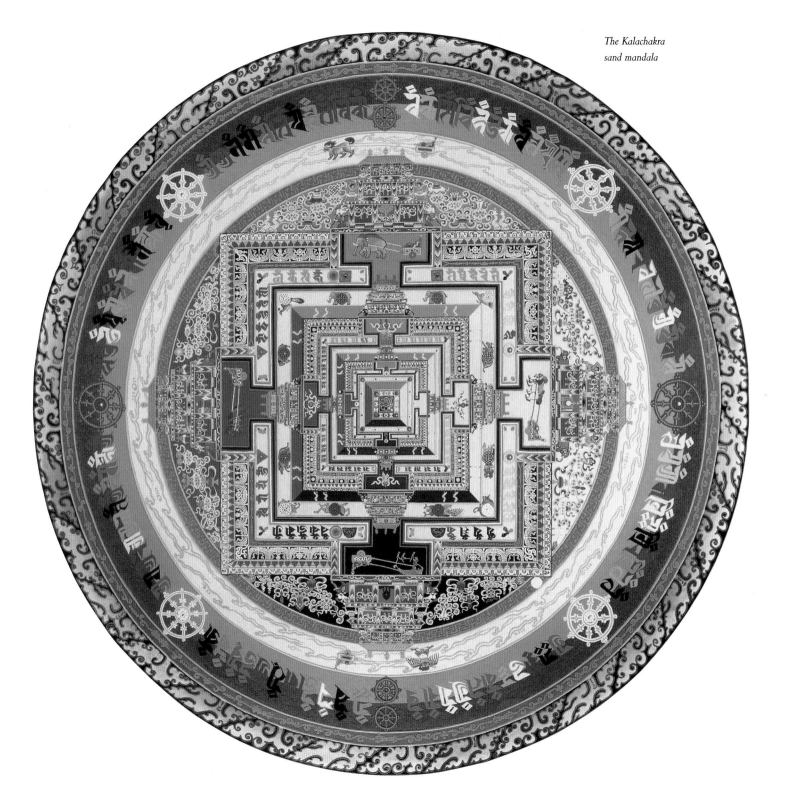

The Kalachakra
sand mandala

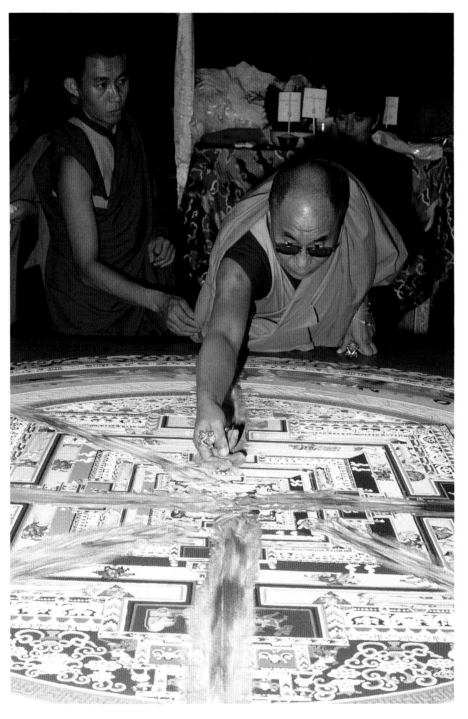

The Vajra Master begins to cut through the mandala along its original spokes.

Halfway inside the mind mandala is a square platform that represents the *enlightened wisdom* mandala. Once in the wisdom mandala, you will find another square platform. This is the highest level of the palace, the *enlightened great bliss* mandala. Within it is the eight-petaled lotus, at the center of which stands the deity Kalachakra embracing his female counterpart, Vishvamata, the All-Mother. Together they symbolize full enlightenment, the union of wisdom and compassion.

Throughout the mandala, you can also find many other identifiable symbols. Twelve animals, located on the lowest level of the palace, are associated with the twelve months of the year. Each animal supports a lotus flower where thirty deities are represented, symbolizing the thirty days of the month. And around the entire palace lie circular bands representing the ancient elements: yellow for earth, a white band with waves representing water, salmon red for fire, gray for wind, and finally the outermost band, representing space and consciousness.

With the Vajra Master guiding their minds and inner eyes, the students of the Kalachakra Initiation become authorized to enter into this perfect palace. But to become enlightened, the students first will have to work hard to perfect their techniques of meditation and their compassion toward all beings.

Since it takes many years of devoted study and meditation to learn the mandala's meaning and imagery, this description is only a simple introduction to understanding Kalachakra. But the philosophy at the highest level of Buddhism is one that anyone can use at any time. This philosophy urges us to reach a splendid, pure inner world while still living in our imperfect, earthly one, using Kalachakra as a model. For example, a pure body comes from eating healthfully and not smoking, drinking alcohol, or taking drugs. Pure speech means not gossiping or saying unkind things about others. A pure mind is trained away from angry, hateful, and selfish thoughts. Once each of us purifies our body, speech, and mind, we can find inner peace. When we have inner peace, at last it is possible to experience the state of bliss, or perfect happiness.

A Ritual Assistant pours the sacred sand into the Hudson River.

PEACE FLOWS INTO THE WORLD

In the last part of the ceremony, on the twelfth day, the Dalai Lama says prayers, thanking the 722 deities for their participation and requesting them to leave the mandala and return to their sacred homes. He removes the sand that symbolically represents the deities, then cuts through the mandala along its original wheel-shaped lines with a ritual implement. The sand is brushed toward the center of the platform and blends in a colorful mix. Then the monks put the sand in urns and transport it to a nearby body of water. With chanting and more prayers, a Ritual Assistant empties the sand into the water, and the perfect peace of Kalachakra flows with it into the everyday world. The mandala, now gone from view, remains forever in the memory of all who entered its perfect realm.

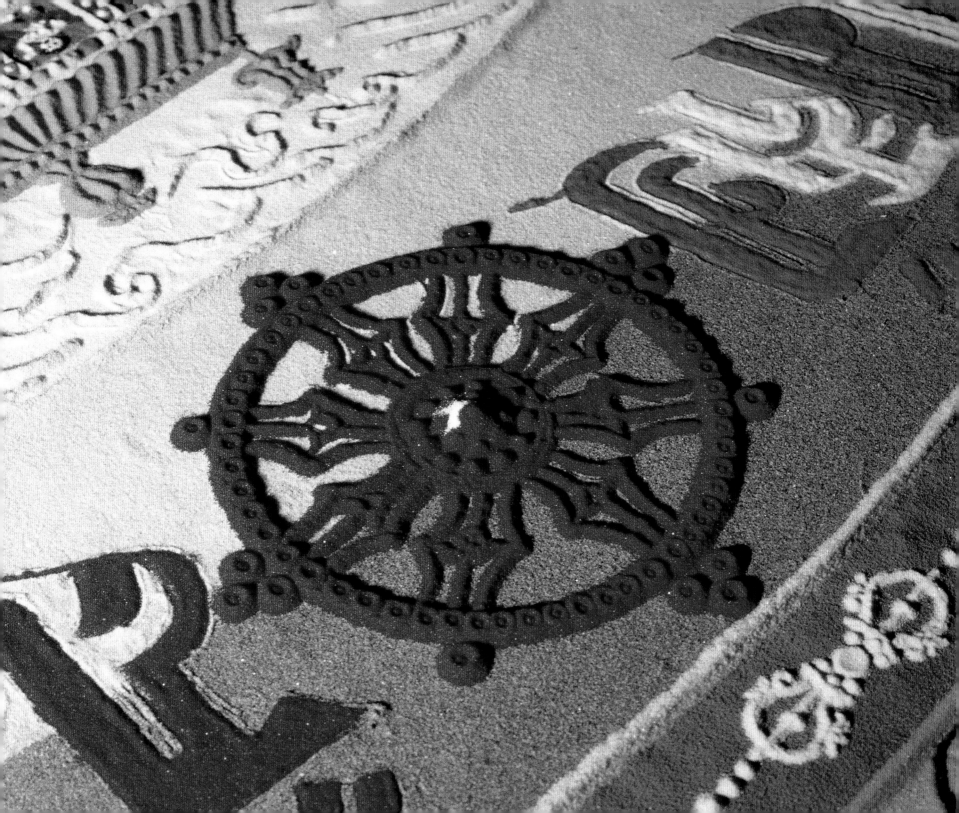

Making Your Own Mandala

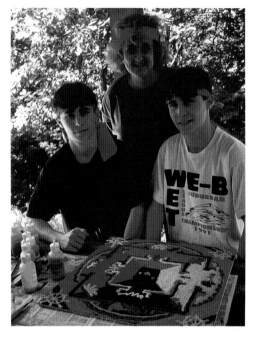

*The author and friends with
their completed mandala*

MATERIALS NEEDED

paper

*colored pencils, crayons,
 markers, or paint*

You can find many beautiful circles throughout nature. Look at the cross section of an orange, the center of a flower, or the iris of an eye. Think of the circular shape of the Earth, the sun, and the moon. Observing and imagining these things will help you design a circular representation of the world you wish to create.

DRAWING A MANDALA

When you blow out the candles on a birthday cake, you make a special wish for yourself. When you create a mandala, you can make a wish for everyone. To design your mandala, you may copy the colors and patterns of the Kalachakra described earlier. Or you can create your own.

Begin by drawing your circle with pencils or markers on a piece of paper. As you draw, think of what you would wish. World peace? To end hunger? To save the rain forests? Next, draw a picture in the center of the circle that shows how the world will look when your wish comes true. Make a series of squares around this center picture, drawing gateways on all four sides of each square. This forms the maze that will lead to your perfect world. Throughout your design, add animals, flowers, and other symbols that are important to you.

CREATING A SAND MANDALA

You probably need at least three other people to help you make a sand mandala. If you like, each of you can wear a red headband as you work.

Place your mandala drawing next to a piece of foam board or other sturdy, flat material. Paint your board red or blue with tempera paint. The chalk lines that you will soon draw will be easier to see against this bright background.

Position one person along each side of the board. These will be the north, south, east, and west gatekeepers of your mandala. Next, rub a generous amount of white chalk onto a piece of string. Stretch the string taut across the center of your board between the north and south gatekeepers and pluck it with your fingertips. A line of white chalk will fall from the string onto the foam board.

As you pluck the string, speak your wish out loud. Snap the string between the eastern and western gatekeepers and again from the northwest corner to the southeast corner. Then snap it from the northeast to the southwest. Each time you pluck the string, repeat your wish for the world. After every couple of snaps, you will need to chalk your string again.

You now have made the spokes of the mandala. From the point in the middle of the circle where the lines intersect, you can use your string and a piece of chalk as a compass to draw the outer circle. Use a ruler or straightedge to draw the guidelines for the squares and doorways in

MATERIALS NEEDED

square piece of foam board or cardboard

tempera paint (optional)

string

white chalk

ruler or straightedge

pencil(s)

colored sand (12 or more colors can be found at craft stores)

plastic squeeze bottles or plain white mailing envelopes

whisk broom or brush

vase or paper bag

red headband(s) (optional)

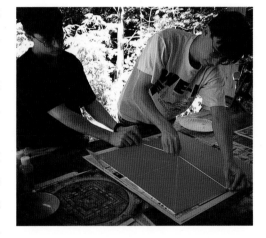

Drawing the initial lines of chalk

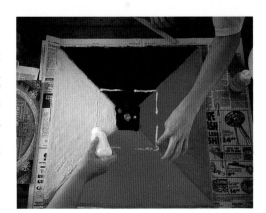

Applying the sand

37

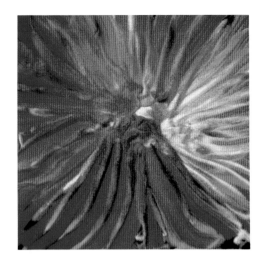

Cutting through the sand along the spokes of the wheel

Releasing the blessing of the sand into a stream

the design. With chalk, you can also draw the outlines of any animals or other shapes from your original picture.

Now you are ready to apply the sand. Fill each plastic squeeze bottle with a single color. (If you do not have plastic bottles, fill an envelope with sand, seal it, and cut a small pouring hole in one corner. This should work almost as well.) Starting at the center of the blueprint, use your sand bottles, one by one, to cover your picture. Try to follow your original drawing as closely as you can.

At first the sand may seem difficult to handle. But with practice and concentration, your work will become easier. Use your fingers to apply large areas of color.

Once you have finished the center picture, each gatekeeper can work in his or her quadrant, always filling in the chalk design from the center outward.

If you make a mistake, brush the sand aside with a straightedge or small brush and reapply the color. To make a straight line, hold a ruler to guide the sand as it flows out of the bottle. Use a pencil or other pointed object to push the sand into smaller, more intricate designs.

When all of the sand has been applied, each of you may remove your headband and "see" your finished mandala.

After you have admired your work for a while, it is time to cut through the mandala following the initial spokes, or lines of chalk. Brush all the sand to the center. Sweep it into a vase or paper bag.

Carry the sand to a body of water such as a stream, lake, river, or ocean. Pour it into the water. As the mandala sand flows away with the current, your wish for the world is carried with it. You have joined your perfect world and this one together!

Glossary

ahimsa nonviolence

bodhi "awake," in Sanskrit; also, a giant fig tree particular to north central India, under which the Buddha sat when he attained enlightenment

Buddha "awakened one"; the name refers to Prince Siddhartha, founder of Buddhism, who lived from approximately 563 B.C. to 483 B.C.

Buddhism one of the major religions of the world, based on the teachings of the Buddha

chakpu a long metal funnel used to apply sand to the mandala design

Dalai Lama the spiritual and secular leader of Tibet

dharma the sacred laws taught by the Buddha

Dharmsala the Himalayan town in India where the Fourteenth Dalai Lama lives in exile with more than one hundred thousand Tibetans

enlightenment the state of perfect wisdom and liberation from all suffering

gelong a fully ordained Tibetan Buddhist monk

gelongma a fully ordained Tibetan Buddhist nun

getsul a novice Tibetan Buddhist monk

getsulma a novice Tibetan Buddhist nun

Kalachakra the "wheel of time," in Sanskrit; a secret and complex teaching of Tibetan Buddhism; also, the deity and the sand mandala associated with this teaching

karma the spiritual law that says the good and bad deeds a person does in one lifetime will affect his or her future lives

Kumbum a monastery in eastern Tibet near the village where the Fourteenth Dalai Lama was discovered

kusha grass the grass that the Buddha was sitting on when he became enlightened; used in Tibetan Buddhist rituals to establish a connection with the Buddha

lama the Tibetan Buddhist term for "master teacher"

Lhasa the ancient holy city and capital of Tibet; historical home of the Dalai Lama

mandala a circle, often enclosing a square, that is a mystical representation of the universe; used in Buddhism as an aid to meditation

meditate in Tibetan Buddhism, to focus one's attention on a single point or object

Namgyal Monastery the personal monastery of the Dalai Lama, located in Dharmsala, India, since 1959

rapjung a boy who is a pre-novice Tibetan Buddhist monk

rapjungma a girl who is a pre-novice Tibetan Buddhist nun

reincarnation the belief that, after death, a person is reborn to live life after life until reaching enlightenment

Sanskrit the ancient sacred language of India

Shambhala the legendary kingdom of King Suchandra

shinga a wooden scraper used in making the mandala

Siddhartha a prince of northern India who lived from approximately 563 B.C. to 483 B.C. and reached enlightenment, after which he became known as the Buddha

Suchandra the king of Shambhala who received the Kalachakra teachings from the Buddha

Tenzin Gyatso the Fourteenth Dalai Lama, born in 1935 and awarded the Nobel Peace Prize in 1989

thekpu the special house where the sand mandala is made

Vajra Master an authorized teacher of the Kalachakra Initiation

Vishvamata the All-Mother; the female Buddhist deity who is the counterpart of Kalachakra

39

Index

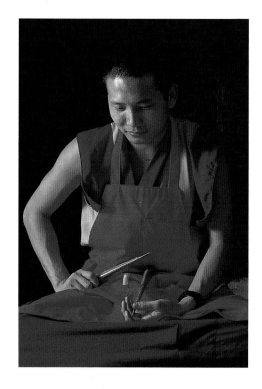